DEVS NOBIS HÆC OTIA FECIT

CITY OF LIVERPOOL
PUBLIC LIBRARIES

PIRANESI
AND
THE GRANDEUR
OF ANCIENT
ROME

THIS IS THE THIRD OF THE
WALTER NEURATH MEMORIAL LECTURES
WHICH ARE GIVEN ANNUALLY EACH SPRING ON
SUBJECTS REFLECTING THE INTERESTS OF
THE FOUNDER
OF THAMES AND HUDSON

THE DIRECTORS WISH TO EXPRESS
PARTICULAR GRATITUDE TO THE GOVERNORS AND
MASTER OF BIRKBECK COLLEGE
UNIVERSITY OF LONDON
FOR THEIR GRACIOUS SPONSORSHIP OF
THESE LECTURES

PIRANESI
AND
THE GRANDEUR
OF ANCIENT
ROME

PETER MURRAY

71

THAMES AND HUDSON
LONDON

© Peter Murray 1971

All rights reserved. No part of this publication may be reproduced or transmitted in any form or by any means, electronic or mechanical, including photocopy, recording or any information storage and retrieval system without permission in writing from the publisher

Printed in Great Britain by Jarrold and Sons Ltd, Norwich

ISBN 0 500 55003 4

In a short lifetime of some fifty-eight years Giovanni Battista Piranesi produced over one thousand etchings. He claimed – although it is hard to believe him – that he had to take four thousand impressions from a single copper-plate in order to make a living, but this figure is far greater than that normally reckoned as the limit of an edition. Certainly he was a superb technician who extended the possibilities of etching beyond anything achieved by his contemporaries, most of whom were technically unambitious. In short, Piranesi produced much larger prints, better engraved, and printed on better paper, than any of his contemporaries; and he produced more of them, in staggeringly large runs, so that he could sell at the equivalent of half-a-crown in the English money of the time. These facts alone justify the dedication of this lecture to the memory of Walter Neurath, whose genius as a publisher lay in the same direction – larger and better reproductions, and many more of them than any of his rivals could produce.

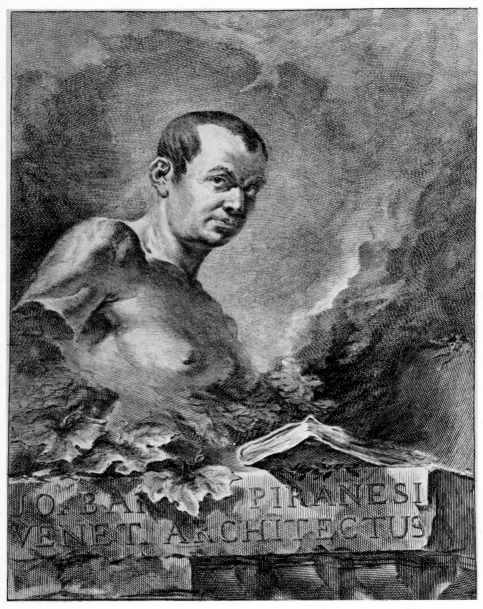

JO. BAP. PIRANESI
VENET. ARCHITECTUS

1 *F. Polanzani*, Portrait of Piranesi, *1750*.

ROME HAS ALWAYS IMPORTED MOST of her artists and scholars, from Raphael and Michelangelo to Gregorovius and Pastor, so there is nothing strange in the fact that Giovanni Battista Piranesi often signed himself *architetto veneziano*, although like St Paul he might well have claimed Roman citizenship. In fact, the description of himself as a Venetian architect is both accurate and informative, and it provides the clue to his artistic formation. Here is the famous portrait (1), engraved in 1750 by his friend Felice Polanzani, as a frontispiece to Piranesi's *Opere varie* of 1750, and re-used for the much more important *Antichità romane* of 1756. Polanzani was a Venetian engraver, twenty years older than Piranesi, whose swelled-line engraving technique was to exert considerable influence on the method evolved by Piranesi himself, combining etching and engraving. The figure, with its nude torso and short haircut, is clearly intended to recall an ancient Roman, like the busts of British worthies by Rysbrack of about the same date, and the Roman lettering of the Latin inscription reinforces this impression.

Piranesi was born near Mestre on 4 October 1720, the son of a stonemason, and died in Rome on 9 November 1778. His uncle, Matteo Lucchesi, was employed by the Magistrato delle Acque, the Venetian department responsible for the upkeep of the sea-walls, and it has been suggested that Piranesi not only learned the elements of building-construction from his uncle, but received a lasting impression from the huge blocks of masonry which had constantly to be repaired against the ravages of the sea. Like many other Venetian architects of the early eighteenth century, Piranesi must have found little prospect of employment, and he turned, perhaps simultaneously, to the means of livelihood that offered itself to others in his position – the fantasy-architecture of the stage, which was then at the height of its splendour and elaboration in the hands of the Bibiena family

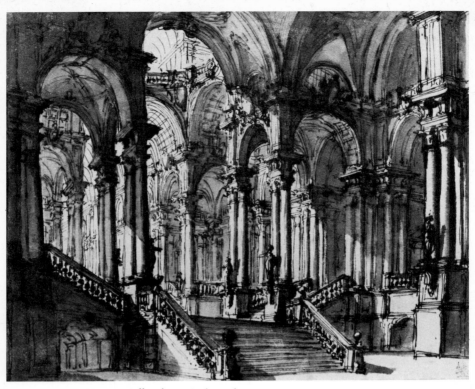

2 *Giuseppe Galli Bibiena*, Atrium, *drawing.*

of Bologna. Piranesi may have studied under one of them – this drawing by Giuseppe Bibiena (*2*) has been attributed to Piranesi – and he certainly knew the engravings of Ferdinando, who published a textbook in 1711, or, even more probably, the *Architetture, e Prospettive* of Giuseppe Galli Bibiena, published in 1740. Piranesi seems also to have worked with the Valeriani brothers, who had studied in their native Rome but were working in Venice in the 1730s. They made this stage-set, which takes to pieces like a toy theatre (*3*).

We do not know whether Piranesi ever practised as a stage-designer, but, when he was twenty, in 1740, he got a chance to go

8

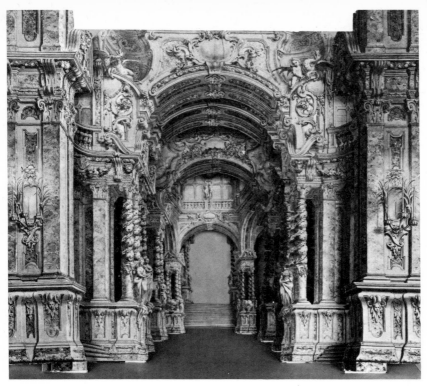

3 *Valeriani*, Stage set, *London. cut-out drawing.*

to Rome as a draughtsman with an official deputation. He stayed
there for about three years before returning to Venice late in 1743,
after which he returned to Rome in 1745 and remained there for the
rest of his life. Before leaving Venice in 1740 we know that he had
already started to prepare himself for his future career by studying
Latin and ancient history under his brother Angelo, a Carthusian
monk. The years 1740 to 1745 were the most important of his life,
and I should like to consider them in more detail.

At the beginning of the eighteenth century, under the influence
of the German Joseph Heintz and the Dutchman Gaspar van
Wittel (known in Italy as Vanvitelli), there grew up a school of

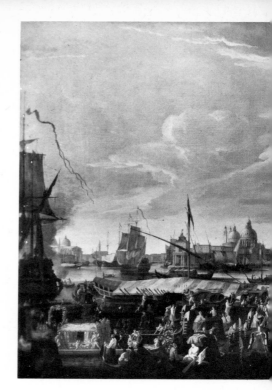

4 *Luca Carlevaris*, The Entry of
the Earl of Manchester into
Venice in 1707, *1708.*

5 *Luca Carlevaris*, Palazzo
Cavalli, *etching from* Le
Fabriche, e Vedute di
Venetia . . . , *1703.*

topographical painters in Venice to meet the demands of the Grand
Tourists, who were beginning to arrive in large numbers. For
Piranesi the most important of these *vedutisti* was Luca Carlevaris,
for he was the first to exploit the etching as a cheap substitute for
a *veduta* painting. His celebrated picture of the *Entry of the Earl of
Manchester into Venice in 1707 (4)* was painted for the Earl, to
commemorate his embassy, which was a political failure but an
artistic success, since he returned to England with Pellegrini and
Marco Ricci, thus beginning a long tradition of English patronage
of Venetian artists from which both Canaletto and Piranesi were to
benefit. This painting is really a history-picture with a topographical
setting; but some years earlier, in 1703, Carlevaris had already
published a suite of one hundred and three etchings of views in

10

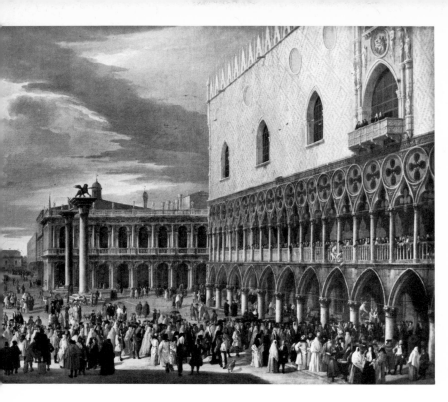

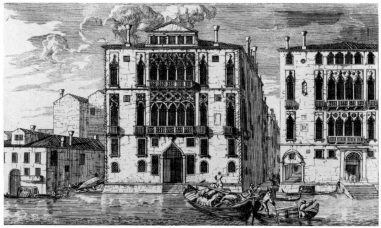

Venice (5).¹ These were clearly intended to be sold quite cheaply, and many of the views can have interested the ordinary tourist only if they happened to represent the *campo*, or even the actual palace, in which he had stayed. These prints are important also because they are etchings, not engravings (although they look as though the burin had been used to strengthen them). In fact, the stiffness and linear quality is very similar to that of a line-engraving made by a reproductive engraver, but this may be due to the topographical, rather than artistic, purpose of the prints. Etching as a means of original expression enjoyed a great revival in Venice in the second quarter of the eighteenth century, at the moment when there were also several highly skilled reproductive engravers and far-sighted publishers active in the city.

When Piranesi was still only fifteen, Canaletto, who was by then an established *veduta* painter, employed Visentini to make a series of engravings (6) of the views of the Grand Canal he had painted for the British merchant, later Consul, Joseph Smith. These engravings

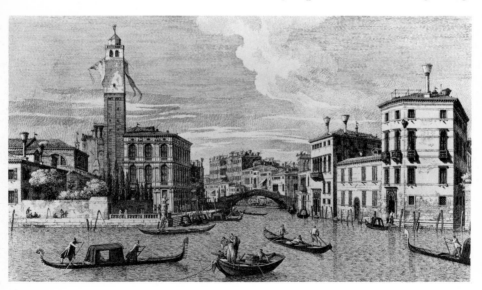

were published as a set of fourteen, entitled *Prospectus Magni Canalis*, in 1735, five years later than the posthumous publication of the etchings by Marco Ricci which he called *Experimenta* (7). These are *capricci*, or what Canaletto later called *vedute ideate*, when, in the 1740s,[2] he published his own series of original etchings, dedicated to Consul Smith, with a title-page which carefully distinguishes between fanciful views – *vedute ideate* – and those made on the spot – *vedute prese da i luoghi*. The etching of the Piazzetta of St Mark's (8) is clearly a *veduta presa dal luogo*, and made from the drawing now at Windsor (9), showing that in these etchings Canaletto kept very close to the actual scene. On the other hand, the *Arch with a Lantern* (10) is equally clearly a *capriccio*, or *veduta ideata*, though founded on close observation. This detail (11), from the *capriccio* dated 1741,[3] shows the simplicity of Canaletto's etching technique, without cross-hatching and with an almost uniform thickness of line, like an engraving. Nevertheless, there is a calligraphic freedom in the line itself, as well as two depths of blackness, due to double biting

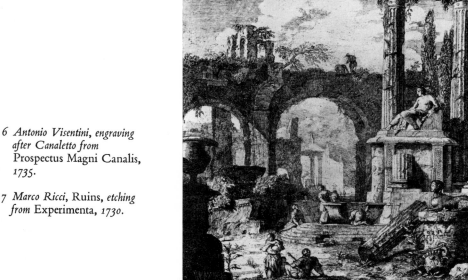

6 *Antonio Visentini, engraving after Canaletto from* Prospectus Magni Canalis, *1735.*

7 *Marco Ricci,* Ruins, *etching from* Experimenta, *1730.*

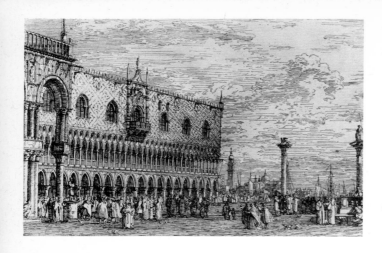

8 *Canaletto*, The
Piazzetta, *etching*,
c. *1744*.

9 *Canaletto*, The
Piazzetta, *drawing*,
c. *1729*.

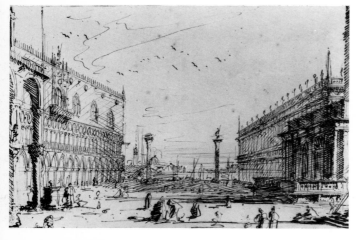

10 *Canaletto*, Arch
with a Lantern,
etching, c. *1744*.

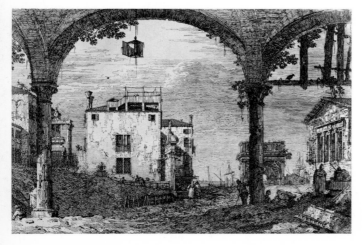

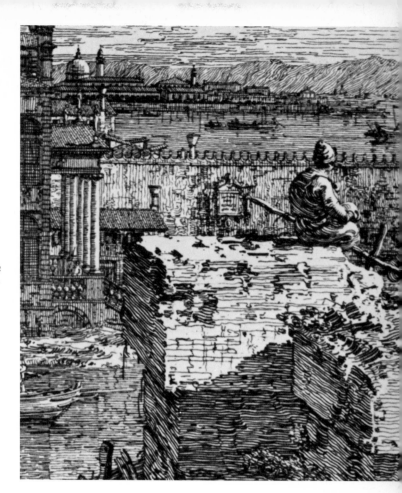

11 *Canaletto, detail from* Imaginary View in Venice, *etching,* 1741.

of the plate and perhaps two sizes of needle, so that there is a personal handwriting beyond the reach of a reproductive engraver. These etchings were, therefore, an indication that an artist could reach a wide market with such original works; especially if he had already secured a public for his ideas with engravings made after his pictures. The early 1740s are crucial in this, for Michele Marieschi also produced, in 1741, a set of etchings of his own paintings of the Grand Canal and other scenes attractive to the tourist – one of the

15

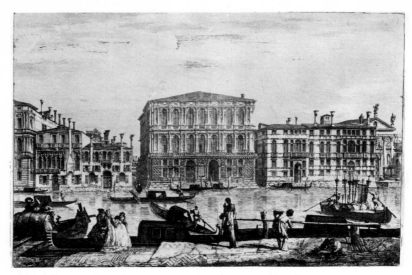

12 Michele Marieschi, Palazzo Pesaro, *etching from* Magnificentiores . . . , *1741.*

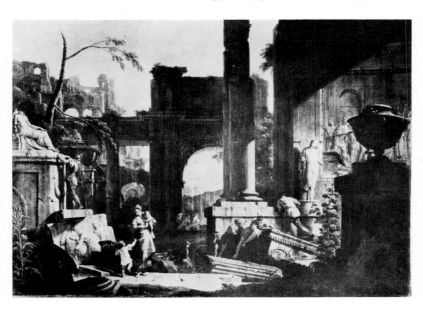

Palazzo Pesaro (*12*) is like the Carlevaris, in that it is a simple view of a building parallel to the picture-plane. It is much more subtle in the handling of light and shade, and the figures are so lively that they have been attributed to Tiepolo himself.[4]

The *vedute ideate* etchings by Canaletto belong to the tradition represented by Marco Ricci in architectural fantasies (*13*), which Canaletto himself occasionally adopted. Of course, the tradition of ruins in a landscape, inducing a pleasing melancholy, goes back a long way in Venice – there is the famous woodcut from the *Hypnero-tomachia Poliphili* of 1499 (*14*), which explains a lot about Piranesi. It is time we returned to him, and the Canaletto of the *Arch of Titus in Rome*, painted in 1742 (*15*), probably from drawings made a year or two earlier, must coincide with Piranesi's first stay in Rome.[5] The Canaletto series of Roman ruins, now at Windsor, is evidently an

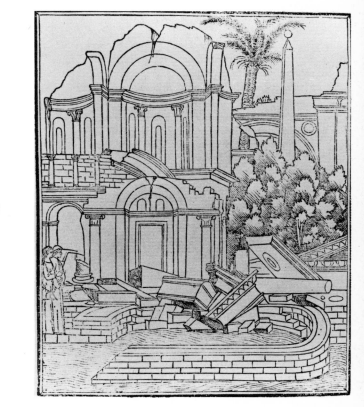

13 *Marco Ricci*, Landscape with Roman Ruins, *1720/30*.

14 *Woodcut from the* Hypnerotomachia Poliphili, *1499*.

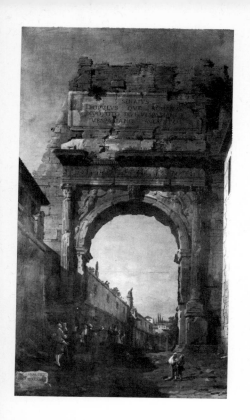

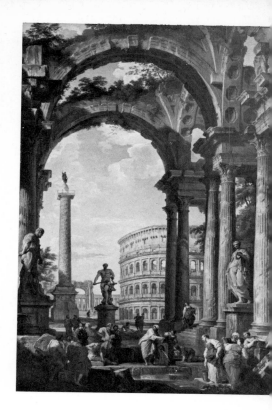

experiment in the classical *veduta* form, inspired by the popularity of Pannini's Roman ruin-pieces. The example of Pannini must have been important for Piranesi when he first arrived in Rome, because Pannini had invented a new type of *veduta*, which was to become very popular, and in due course he became Principe of the Accademia di San Luca, the ultimate seal of respectability. Pannini's earliest documented oil-paintings were done for the architect and stage-designer Juvara in 1723, and by 1740 he had established his own genre; but it is important to distinguish between the various types he employed. The *capriccio* properly so called is represented by paintings (16) which contain a collection of accurate representations of ancient buildings and sculpture, but are arranged capriciously to

18

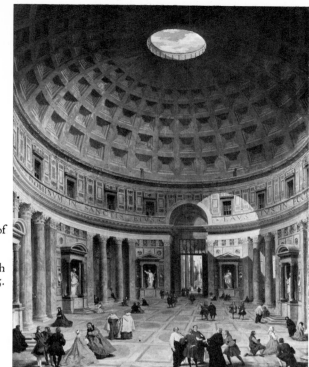

15 *Canaletto*, The Arch of
 Titus in Rome, *1742*.

16 *Pannini*, Capriccio with
 the Colosseum, c. *1745*.

17 *Pannini*, Interior of the
 Pantheon.

18 *Pannini*, The Death of
 Marcus Curtius,
 c. *1730*.

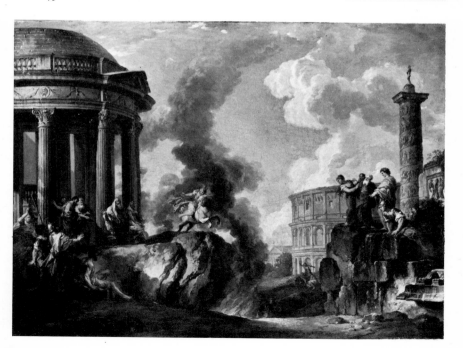

make a pleasing medley rather than a record of fact. The popularity of this kind of tourist souvenir is attested by the number of surviving examples. On the other hand, he also painted strictly accurate delineations of famous buildings – the Pantheon (*17*), St Peter's, Sta Maria Maggiore – and some pure fantasies of ancient Rome, which might be described as Rococo History. An example is the *Death of Marcus Curtius* (*18*), where one might be forgiven for casting Senesino and Farinelli in the principal roles. In fact, Pannini had begun by studying the works of Bibiena, though many years before Piranesi did, so the stage connection constantly recurs. There are two drawings in the Royal Institute of British Architects which

19 *Piranesi, drawing after Juvara's scenery for* Teodosio il Giovane, c. *1747/53.*

actually show the moment of transition from stage-design to Roman *capriccio*.[6]

We now know, thanks to Mr Croft-Murray, that Piranesi did, on occasion, make free copies of Juvara's stage-sets, based, in this case (*19*), on the engravings in the published *libretto* of Filippo Amadei's opera *Teodosio il Giovane*, of 1711.[7] During his first Roman period Piranesi seems to have been more intent on stage-design, perhaps as a stepping-stone to architectural commissions, than on the topographical and archaeological work that was to bring him fame; and, in 1743, probably directly inspired by Giuseppe Galli Bibiena's *Architetture, e Prospettive* of 1740, he published his

first independent work, the *Prima Parte di Architetture e Prospettive*. The second part never appeared, but in 1750 he issued all these plates, and several others of the same type, under the title *Opere varie*. Plate *20* is from Bibiena's book, and ostensibly represents Christ before Caiphas:[8] Longhi's acid description of a picture by Tiepolo as 'Saint Thecla, soprano; God the Father, bass' would seem to apply here. By contrast, Piranesi's *Royal Atrium* (*21*) is less stagy and much freer in handling; this, however, is one of the plates added after 1745, and the original 1743 plates, such as the *Stairs* (*22*) and

20 *Giuseppe Galli Bibiena,*
Christ before Caiphas,
from Architetture, e
Prospettive, *Part III, no.
4, 1740.*

21 *Piranesi,* Atrio reale (*Royal
Atrium*), *etching from* Opere
varie, *1750.*

22 *Piranesi,* Gruppo di Scale
(*Stairs*), *etching from* Prima
Parte di Architetture . . . ,
1743.

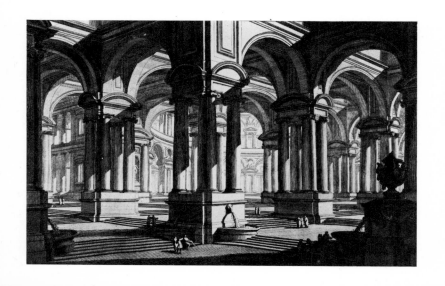

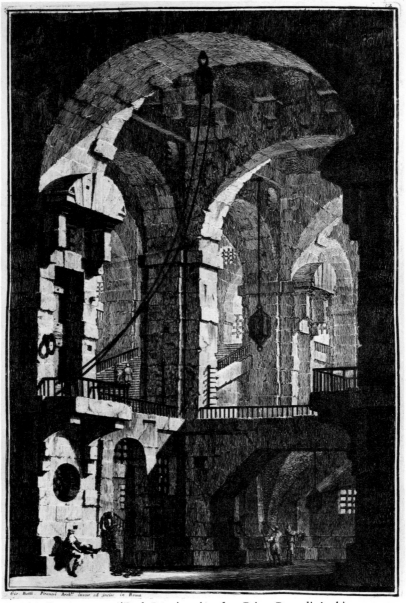

23 *Piranesi*, Carcere oscura (*Dark Prison*), *etching from* Prima Parte di Architetture, *1743*.

the *Dark Prison* (*23*) are still very stiff and close to the Bibiena type.[9] The fact that one actually represents a prison – it is entitled *Carcere oscura con antenna pel supplizio de' malfatori* – brings the second act of *Fidelio* to mind – 'Gott! welch' Dunkel hier!' – although the prison scenes in Handel's *Theodora* would be chronologically more appropriate.[10] The theme is once again derived from the Bibiena family, as may be seen by comparison with an engraving (*24*) of about 1703/8 by Ferdinando Bibiena, or a watercolour (*25*) of a prison scene, also by Ferdinando. Both of these show Ferdinando's major theatrical innovation, the *scena per angolo*, or scene set at an angle so that the perspectives run off diagonally at either side.[11] This device was to be exploited by Piranesi in his views, as well as in works of this kind.

The 1743 *Carcere oscura* is, of course, no more than a prelude to what is nowadays regarded as Piranesi's masterpiece, the *Invenzioni capric. di Carceri* of 1745 to 1750, retitled *Carceri d'Invenzione* for the second, enlarged, edition of 1760. The original set of fourteen plates must have been made about 1745, immediately after Piranesi's return to Rome, and while still under the influence of Venetian art. They were issued about 1750 by the French publisher in Rome, Bouchard, who subsequently issued many other works by Piranesi, although the

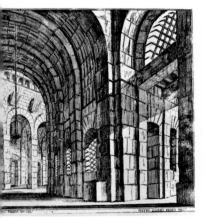
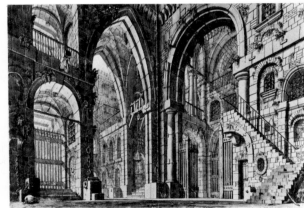

24 Ferdinando Bibiena, Prison interior, *engraving, 1703/8.* *25 Ferdinando Bibiena,* Prison, *watercolour.*

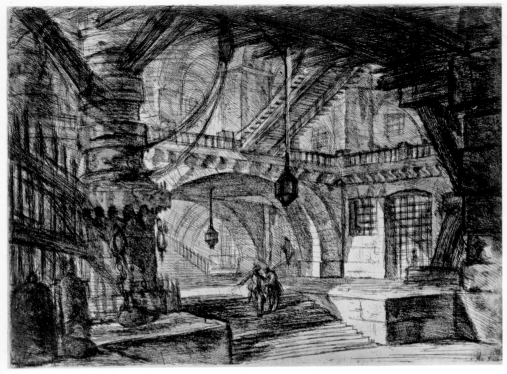

26 Piranesi, first state of Carceri d'Invenzione, *etching, 1745–50.*

second set of the *Carceri*, of sixteen plates, appears to have been published by Piranesi himself.[12] Plates *26* and *27* show how much the two editions differ, since plate *26* is the first state of plate *27*, and whole passages in the centre have been burnished out and reworked. The *Carceri* have been analyzed often enough, and they are not really germane to my subject, so I shall say no more than that I believe they have been largely misinterpreted in a Freudian sense, since no account has been taken of their origin in the world of opera. The theme of the dungeon, from Bibiena to Beethoven, might make an interesting essay, but it would need to start from the fact that prison cells were not, for an educated man in the eighteenth century, quite so grim

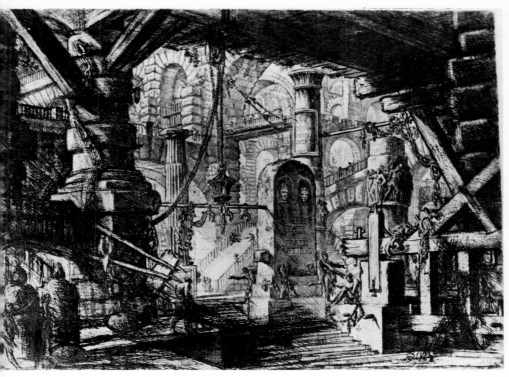

27 Piranesi, *second state of the same* Carceri d'Invenzione, *1760.*

a possibility as they had been in the sixteenth, or are in the twentieth century. Whatever else may be said against the eighteenth century, the penalties for not holding 'correct' opinions were less terrifying than in the earlier or later periods. Yet I do not mean that Piranesi treats his prisons as a Rococo extravaganza, for he is not a Rococo artist, and his works have a quality of seriousness which makes them, for me at any rate, superior to those of his imitators like Hubert Robert, as well as predecessors like Pannini. He did, after all, live in the *ernst* atmosphere of Winckelmann's Rome. It is true that his intensity of feeling sometimes – perhaps even often – verges on melo-drama, but the romantic contrast between decayed architecture and

27

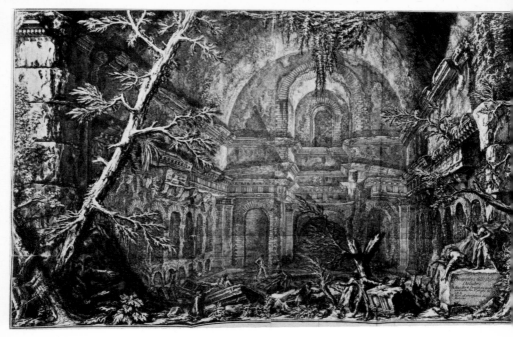

28 *Piranesi*, II Delubro, *etching from* Descrizione e disegno dell'Emissario del Lago Albano, *1762*.

dead nature in a plate from the Lake Albano series (*28*) of 1762, would not have been possible without the contrasts of form and of light which are the artistic justification of the *Carceri*.

There seems to be no direct evidence for Piranesi's connection with the Tiepolo studio in Venice during his return there in 1744, at the time when Tiepolo was working on his huge *Banquet of Cleopatra*, now in Melbourne, as well as the ceiling fresco for the Scalzi church. From our present point of view, it is more important that it has recently been established that Tiepolo's first suite of etchings, the *Capricci*, was published in 1743 (and not 1749, as used to be thought),[13] so that they were probably in production while Piranesi was in the studio: indeed, they probably explain the stylistic connection between the two men.

In spite of their cheerful-sounding title, death and decay form an important element in these etchings, as the skeleton (*29*) eloquently

28

demonstrates, and it is largely on account of this sense of imperma-
nence, of the lurking worm, that Tiepolo is sometimes a great
religious painter.[14]

In Piranesi's gay Rococo cartouche (*30*) the marble is crumbling
and skulls are scattered across the foreground. The sense of decay is
both pleasing and terrifying, and we remember that the notion of the
Sublime was being defined by Edmund Burke at this moment;[15] a
death's-head can hardly be Picturesque, yet these are undeniably
prettier than they would have been in the seventeenth century. In
Piranesi's work, here and later, the boundaries of the Picturesque
and the Neoclassic seem coterminous, but this is not really so – the
two categories are distinct, though many works of art, and not only
Piranesi's, partake of both. A Sharawaggi garden is not Neoclassic,
and David's *Horaces* is not Picturesque. In these etchings of about
1745–50 Piranesi appears as a serious artist, perhaps for the first time.

The years between 1745 and 1750 were difficult for him. He
returned to Rome with the encouragement of the German Venetian,

29 *G. B. Tiepolo*, Capriccio, *etching, 1743 or earlier.*

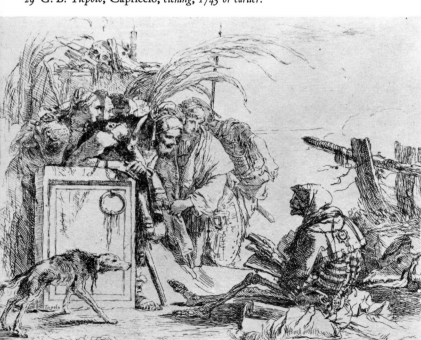

Wagner, whose agent he became as a print-seller, while at the same time he began an independent career as an engraver of *vedute*. By 1744, for example, he had engraved a plate from a drawing by Francesco Zocchi for his book of views of Florence and its environs,[16] but, about 1745, he began to make small etched views of Rome for sale as single prints, or as sets bound up in albums. In 1745, as we now know,[17] there appeared a volume called *Varie vedute di Roma antica e moderna . . .*, not to be confused with the much more famous *Vedute di Roma*, which began only in 1748. The *Varie vedute* has about ninety plates, of which some fifty are by Piranesi. A new edition was published in 1752 with a new title-page, which describes the plates as 'mostly by the celebrated Giambattista Piranesi, and by other engravers'. Making every allowance for a publisher's blurb, this seems to indicate that Piranesi was quite famous by 1752, the year of

30 Piranesi, Capriccio, *etching, c. 1743?*

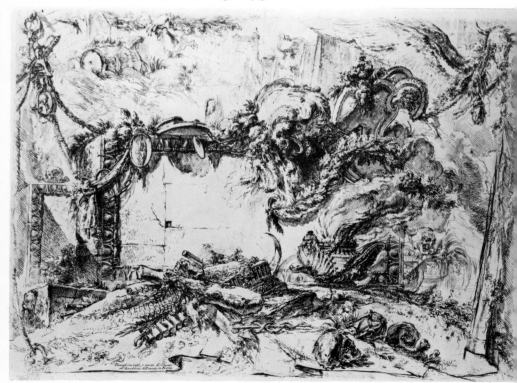

his marriage and the start of his greatest enterprise. In the 1745 edition, however, there were several plates by others, the earliest one being dated 1725, by Paolo Anesi, who was active as a topographical painter and engraver in Rome from that year until his death in 1766. Several other plates are by a group of French artists, mostly *pension-naires* of the French Academy in Rome, with which Piranesi, like Pannini, maintained a close connection. Before we consider the relationship between these artists and Piranesi, however, we ought to look at examples of the work of Jean Barbault and Giuseppe Vasi, both of whom have close but ill-defined relationships with Piranesi.[18] According to the early sources, Piranesi was a pupil of Vasi, but threatened to murder him because, he claimed, Vasi had kept back from him certain technical secrets of etching. This, I'm afraid, is typical of the early sources, which play up the volcanic side of Piranesi's character. This undoubtedly existed, but the early *Lives* date from about 1780 onwards, and it is not surprising if they seem to show his temperament as fully Romantic.

In fact, Vasi's work consists of a huge and justly famous map of Rome, dated 1765, an endless series of dreary machines for miscellaneous State occasions, and the *Magnificenza di Roma antica e moderna* – a title later adapted by Piranesi – which consists of more than two hundred plates in ten volumes, published between 1747 and 1761. One plate, the *Trevi Fountain*, is dated 1746, and is a sort of pallid premonition of Piranesi's versions of 1751 and 1773. The *Campo Vaccino (31)* shows that, like Piranesi, Vasi had realized that there was a huge market for tourist engravings, but all his work has the same rather unadventurous technique of evenly engraved lines, reminiscent of the Carlevaris etchings of Venice. They show that he knew no secrets of technique, and indeed he did not even have the wit to learn from Piranesi.

Jean Barbault was a French history-painter and engraver, some fifteen years older than Piranesi, who arrived in Rome at his own expense about 1742, became a *pensionnaire* of the Academy, and spent the rest of his life in the city, dying there in 1766, five years

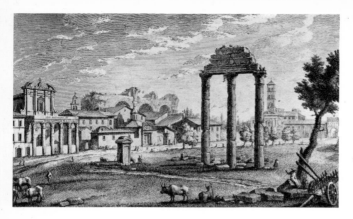

31 *Giuseppe Vasi*, Campo Vaccino, *etching from* Magnificenza di Roma antica e moderna, *1747*.

32 *Jean Barbault*, The Portico of Octavia, *etching from* Les plus beaux Monumens de Rome ancienne, *1761*.

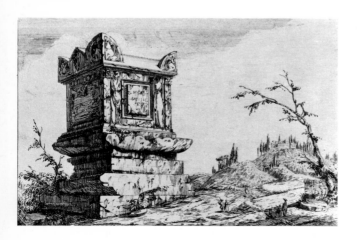

33 *Charles Bellicard*, Nero's Tomb, *etching dated 1750 from* Varie vedute.

34 François Philotée Duflos, Temple of Bacchus, *etching from* Varie vedute di Roma antica e moderna, *first published 1748.*

after publishing *Les plus beaux Monumens de Rome ancienne,* which includes this *Portico of Octavia (32).* It at least shows that he was not an innovator and was content to follow in the path laid down by Piranesi. It is an accomplished piece of work, but who now remembers Jean Barbault?

To return to the problem of the 1745 *Varie vedute,* with its plates by the older Anesi and various young Frenchmen, there is a view, *Nero's Tomb (33),* by Charles Bellicard, who won the Prix de Rome in 1747, at the age of twenty-one. Obviously, he could not have taken part in the original edition of 1745, and the plate is in fact dated 1750. What interests me about it is that I doubt whether I could distinguish it from the work of Stefano della Bella, or from a similar classical landscape[19] in the Gaspar Poussin tradition by Nicolas Perelle, who was working some eighty years earlier: in other words, there existed a Franco-Italian convention for the representation of classical landscape, which, at this date, had hardly been affected by Piranesi. Bellicard later returned to Paris and became an architect, as did another contributor to the *Vedute,* Le Geay, whose career has recently been explored by Mr John Harris.[20] The etching (34) is by yet another young French artist, François Philotée Duflos, who won the Prix de Rome in 1729 and arrived about 1733. He is now remembered mainly for these etchings, and perhaps also for the mention of him in a report made, some thirty years later, by the then Director of the French Academy in Rome, in which he is

33

quoted as an example of a man who spent eight years as a *pensionnaire* and the result was that he did very little and returned to France as a mediocre landscape-painter.[21] This was perhaps unkind, as Duflos returned to Lyons and died there in 1746, so these etchings were actually published posthumously. The signed *Temple of Bacchus* is very close to Stefano della Bella, more so perhaps than one of the *Basilica of Maxentius* (35), which is reasonably attributed to him by Mr Osbert Barnard.[22]

I chose this view of the Basilica because it makes an interesting comparison with an earlier version, also by a Frenchman, Etienne Dupérac, active two hundred years earlier (which gives an insight into the durability of the tourist market in Rome). In the Dupérac

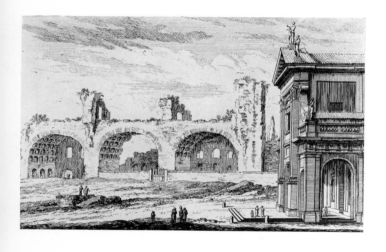

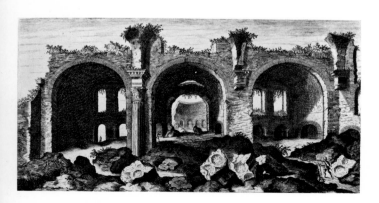

35 *François Philotée Duflos*, Basilica of Maxentius, *etching from* Varie vedute di Roma antica e moderna, *first published 1748.*

36 *Etienne Dupérac*, Basilica of Maxentius, *engraving from* I Vestigi dell'Antichitá di Roma, *first published 1575.*

37 *Piranesi*, Basilica of Maxentius, *etching from* Vedute di Roma, *1757.*

(*36*) the ruins are seen exactly parallel to the picture-plane, and the feeling of scale is given mainly by the heaped-up fragments in the foreground. In foreground, middle distance, and background there are tiny figures, but they somehow fail to impress us with the size of the actual ruins, and the same is true of the Duflos, where the introduction of the church seems, if anything, to diminish the importance of the Basilica itself. Perhaps the most interesting thing to emerge from the comparison is the change in the state of the ruins which two centuries had brought about. (The column is still shown as standing in the Dupérac.)[23] If we now turn to an early version of the same subject by Piranesi, the plate from his *Vedute di Roma* etched in 1757 (*37*), his superiority is manifest. He has adopted the *scena per*

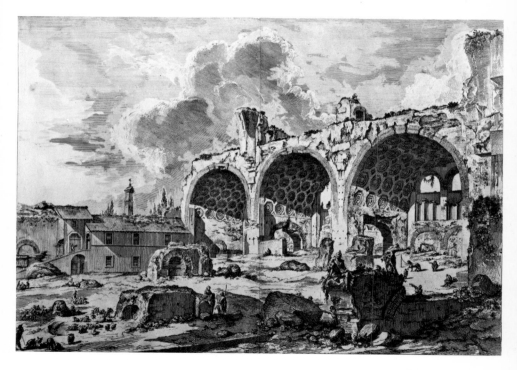

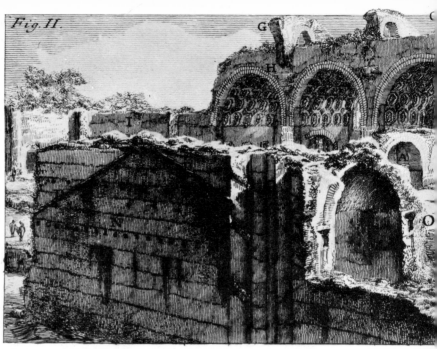

38 *Piranesi*, Basilica of Maxentius, *etching from* Antichità romane, *1756*.

angolo perspective of Bibiena, at once giving depth to the composi-
tion, and, by the foreshortening, apparent extent to the vast mass of
masonry. Instead of contrasting it with a large church, he uses a
small house. Finally, the figures in the foreground attract attention to
themselves by impetuous gesticulation, probably theatrical in origin,
so that not only does their impatience give a feeling of eternity to the
brooding ruins, but the way in which they draw attention to them-
selves indicates how petty they are. Technically, the plate is still
simple, with only a light biting over most of the area and a second
biting to give extra blackness to the foreground. A year or two earlier,
Piranesi had produced a much smaller version of the same subject
as an illustration to his *Antichità romane* of 1756 (*38*), and here
the parts are all given letters to identify them, since this is an
archaeological demonstration rather than a *veduta*. The principal

36

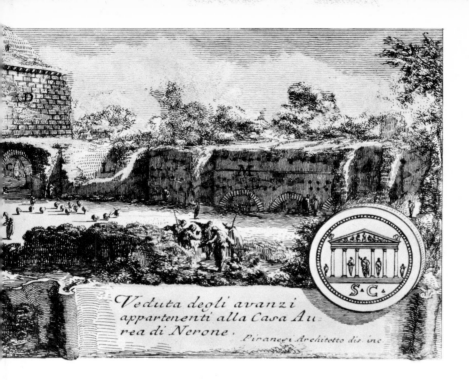

Veduta degli avanzi
appartenenti alla Casa Au
rea di Nerone. Piranesi Architetto dis. inc.

difference is in the strength of light and shade, but this again has a theatrical quality about it. In yet another version, this time another of the *Vedute di Roma*, but of 1774 (*40*), seventeen years later than the first one, we can see how, in his late style, the scenic perspectives have become nearly – but not quite – untruthful. Not only is the perspec⁄tive itself somewhat dramatic, but the contrasts between the huge dark mass of the Basilica with its great light⁄filled openings and the pale, small houses glimpsed through them, and the race of pigmies who strut about in the foreground, are, so to speak, a lesson on the theme 'There were Giants upon the Earth in those Days'. These figures by Callot (*39*) might have stepped out of a late Piranesi, and indeed it seems that he must have known Callot's work quite well, perhaps through his French friends. In fact, of course, there are also many echoes of Callot in the etchings of both Ricci and Tiepolo.

37

39 Jacques Callot, etching from Les Caprices, *1617/21.*

40 Piranesi, Basilica of Maxentius, etching from Vedute di Roma, *1774.*

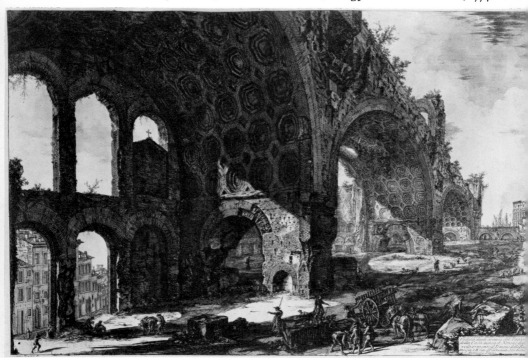

If we look at a photograph of the same building (*41*) the sense of excitement vanishes. It is easy to see why many artists, Flaxman and Goethe among them, felt vaguely let down by the actuality when their imaginations had been warmed by Piranesi. How many other Northerners came to Rome ready to be impressed, simply because they had already glimpsed something which gave life and colour to their endless Latin lessons?

The *Aqueduct of Nero* (*42*), of 1775, deals with a subject which provides an even greater opportunity for virtuoso foreshortening and aerial perspective, but I have chosen an example printed not earlier than 1870 – about a hundred years and countless impressions after it was made (*43*).[24] If Piranesi's estimate of four thousand impressions is anywhere near accurate, this plate must have been rebitten and reworked several times. In the opinion of one expert,[25] Piranesi sometimes used as many as ten or twelve bitings, as well as different shapes and thicknesses of needle, though I have never myself seen

41 Photograph of the Basilica of Maxentius.

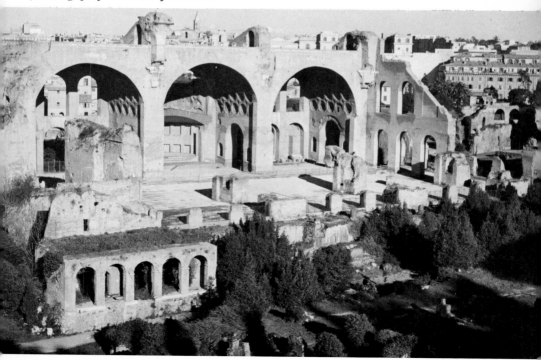

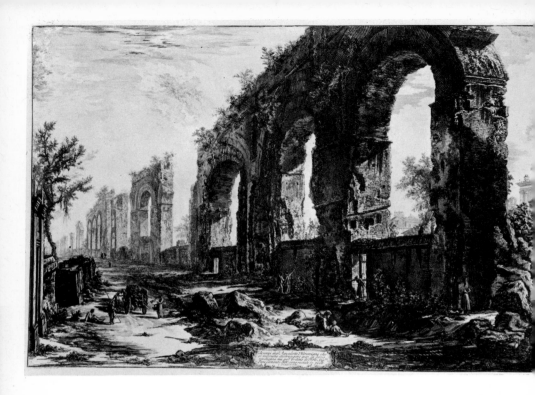

evidence of so many bitings. In the case of a much-worn plate like this, the reworkings probably also include the use of a burin in the very dark passages, which here (*44*) look almost like the wood-engravings of Gustave Doré, since the white parts now appear as strokes against a black ground, the reverse of normal etchings. A burin might, perhaps, also have been used for the most delicate passages, such as the roof of the house in the background as well as the horizontal hatching on the wall in the foreground. The detail shown in Plate *45* is from a much earlier etching, of 1760, in an early state, and it shows how Piranesi's style developed from the evenly spaced linear shading, without cross-hatching, of his Venetian training towards a much more dramatic variety of texture.

What is particularly interesting about this stylistic development is a chicken-and-egg question: all the earliest *Vedute*, from 1748 to the

40

late 1750s or even later, are relatively pale in their general tone; indeed, many dealers say that the very earliest and finest impressions are less popular than the more impressive dark late ones. But was this because Piranesi's style, impelled by the inner logic of his own development, was moving towards an ever more dramatic statement – Proto-romantic, if you like? Or is there a more commonplace solution? He did, after all, have to rework his earliest plates in order to get enough impressions for sale, so that they automatically became darker and richer in tone. When, in say 1770, he sold a collection of his *Vedute*, made up from early and more recent plates, he had late impressions of the early plates alongside very early impressions of his most recent plates, so that, for the sake of consistency, he probably made his later works somewhat darker to begin with.

42 *Piranesi,* Aqueduct of Nero, *etching from* Vedute di Roma, *1775, in an impression made in or after 1870.*

43 *Detail of pl. 42.*

44 *Detail of pl. 42.*

45 Piranesi, *detail from* Portico of Octavia, *etching from* Vedute di Roma, *1760.*

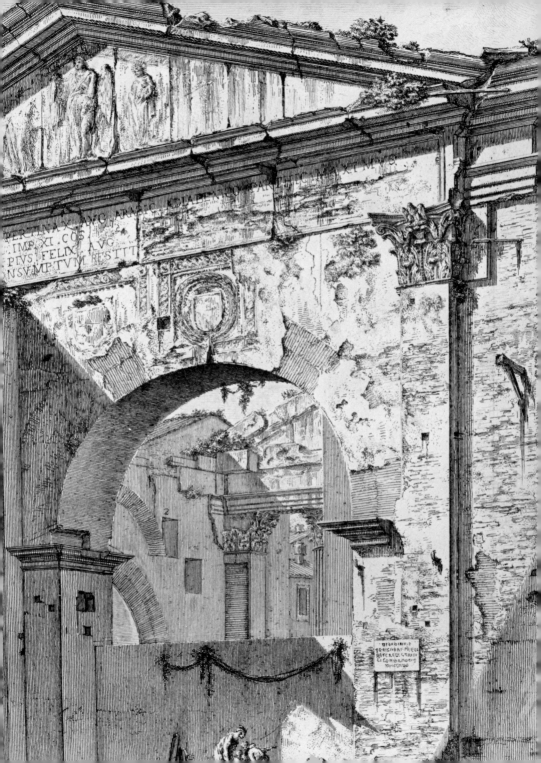

With the last few examples I have jumped about in time, and we ought to pause for a moment to put the chronology straight. After the 1745 *Varie vedute* Piranesi began three other undertakings which are often confusing because of the similarity of title: the small *Varie vedute* of 1745 were succeeded, from 1748 to the end of his life thirty years later, by the series of one hundred and thirty-five single prints, known collectively as the *Vedute di Roma*, which are his best-known works.[26] These, which were sold singly at about half-a-crown each, or in bound-up sets, are very much bigger than the *Varie vedute*, being roughly fifteen by twenty or more inches against the four and a half by seven of the earlier set. In the same year, 1748, he began a series of views of the antiquities, called *Antichità romane de' tempi della repubblica e de' primi imperatori*. . . . This was dedicated to Mgr Bottari, the learned art historian who was Librarian of the Vatican and who had encouraged Piranesi ever since his first stay in Rome. This *Antichità romane* should not, however, be confused with his major work of scholarship, the *Antichità romane* published in four huge volumes in 1756.

The *Vedute di Roma* have been catalogued and dated with great precision, so that we can follow Piranesi's career as a maker of tourist *vedute*. Originally, these were planned to provide large, splendid, and cheap souvenirs of the main sights of modern – that is, mainly seventeenth-century – Rome. There is very little of medieval or Renaissance Rome, though the most recent architecture was repre-sented by the Piazza di Spagna and the Trevi Fountain. The first thirty plates, issued one at a time between 1748 and 1754, are exclusively of modern Rome and of popular subjects such as the great Basilicas, starting with several plates of St Peter's, the Piazza Navona, the Piazza del Popolo, the Quirinal, the Trevi Fountain and so on. *The Arch of Constantine and the Colosseum* (46), of 1760, is a good example of this kind of etching, but it belongs to the second phase, starting about 1754, in which subjects from ancient Rome begin to occupy an important place: the next thirty plates, dating between 1754 and 1760, show twenty-eight ancient monuments

44

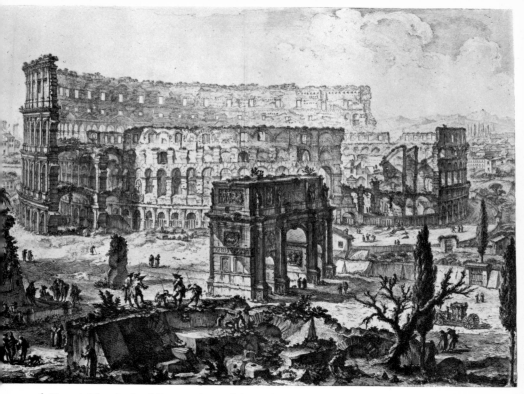

46 Piranesi, The Arch of Constantine and the Colosseum, *etching from* Vedute di Roma, *1760.*

against two modern. Both (*45*) and (*46*) are among the latest works in this group.

The reason for this switch in subject-matter is that from before 1752 until 1756 Piranesi was devoting most of his formidable energy to the vast undertaking of drawing and measuring the ruins and engraving the huge plates – over two hundred of them – for the volumes of his *Antichità romane*. In 1752 he married, after a celebrated five-day courtship, and we are told that he spent his bride's small dowry on copper plates. Bottari and other antiquarian friends got him a tax exemption for the special paper he imported for the project, and in 1756 he issued all four volumes together. The plates must be

among the largest ever etched, many being over two feet across, and they are obviously more influenced by large-scale architectural publications such as Desgodetz's *Edifices Antiques de Rome*, of 1682, or the de' Rossi *Architettura Civile*[27] of the first years of the eighteenth century, than by small-scale *vedute* such as his own earliest works. The effect was immediate. From being an engraver of tourist *vedute* Piranesi became a European celebrity. The Minute Book of the Society of Antiquaries of London records, on 24 February 1757, 'Il Signor Giovanne Battista Piranesi, a Venetian, resident [also] at Rome, a most ingenious architect, and Author of the Antiquities in Rome and its Neighbourhood in V Vols. Folio, and desirous of being admitted an honorary Member of this Society . . .'[28] He was duly admitted at the April meeting, and it is pleasant to think that the Antiquaries recognized his merit so quickly. Piranesi had chosen his moment of publication well. Lodovico Antonio Muratori had published his monumental *Rerum Italicarum Scriptores* between 1723 and 1738 and his *Antiquitates Italicae Medii Aevi* between 1723 and 1751. In 1755 Winckelmann had published, in Germany, the most influential pamphlet of the century, his *Gedanken über die Nachahmung der griechischen Werke* . . ., and since then he had come to live in Rome.

The *Foundations of the Mausoleum of Hadrian, or Castel Sant'Angelo* (47) is from the fourth volume of the *Antichità romane* and is the quintessence of Piranesi. It is a large plate, representing nothing but huge masses of masonry with a few tiny figures – one hardly notices the minute figures balanced on the outcrop at the upper right corner. The cyclopean masonry is in decay, but because of this the skeletal forms are revealed in all their awe-inspiring strength. In the foreground a lump of masonry projects into our side of the picture-plane, a theatrical device for involving the spectator in the action, which shows that Piranesi's approach, subconsciously perhaps, was slightly different in his illustrations from the approach in his writings. From the mortality of Hadrian's Mausoleum immortality arises, and the activities of a few men in tricorne hats seem as ephemeral as gadflies.

47 *Piranesi*, Foundations of the Mausoleum of Hadrian, or Castel Sant'Angelo, *etching from* Antichità Romane, *1756.*

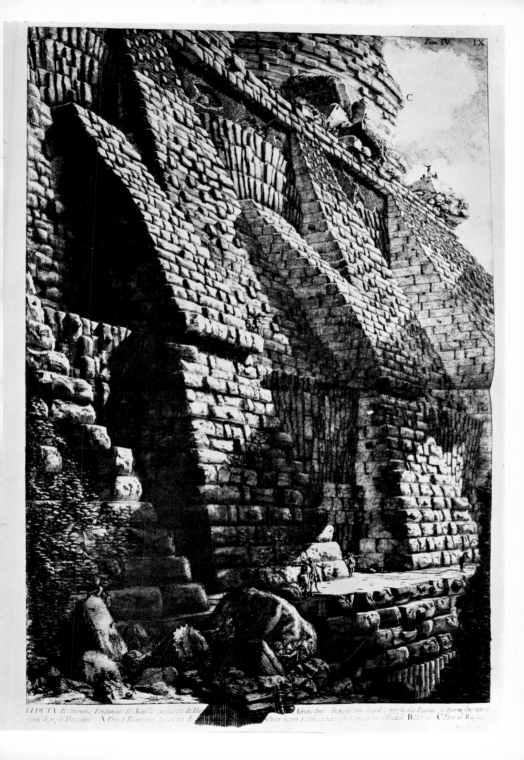

VEDUTA del sotterraneo Fondamento del Mausoleo, che incrostato di Pie... ...Linea Imp.a In questa parte, la qual e opposta alla Facciata si scorgono fino tutti... ...mita di questi Travertini. A Pezzi di Rampante comessi in... ...Opera incerta a scun da entrarvi con gran giro nella Finaich. B Sitento. C Pare di Bas..

48 Piranesi, Baths of Diocletian, *etching from* Antichità Romane, *1756.*

The *Antichità* contains a small number of plates like the *Hadrian's Mausoleum* or the *Baths of Diocletian* (*48*), which are works of art in their own right, but it also has many others which are simply records of inscriptions – yet it was methodologically correct to render them as facsimiles rather than merely to reproduce the text typographically; and we must remember that Piranesi was also one of the first archaeo‐logists to make serious use of the so‐called 'Marble Plan' of ancient Rome, which had been lying about in the Palazzo Farnese since 1741.

On the other hand, many of the *Vedute* of this period begin to reflect their creator's archaeological interests, and (*49*), wrongly iden‐tified as the *Forum of Nerva*, was made in 1757 as part of the *Vedute di Roma* series, but it is a study of ancient masonry exactly like the *Hadrian's Mausoleum*, even down to the *quadratura* effect of the projecting fragment in the foreground.

49 *Piranesi*, 'Forum of Nerva', *etching from* Vedute di Roma, *1757*.

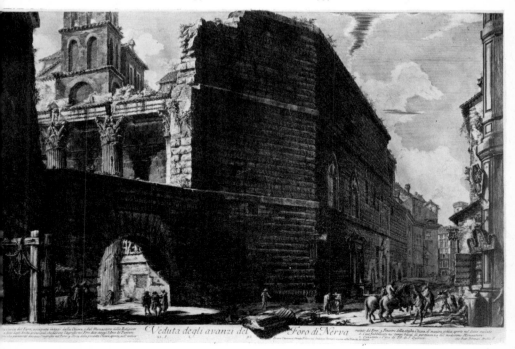

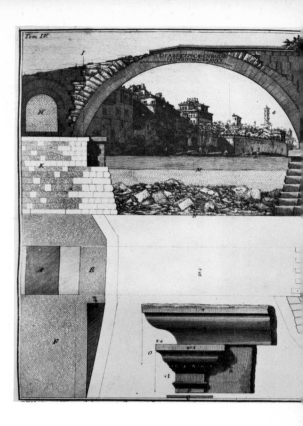

Two more plates from the *Antichità* (*50*, *51*), of the Pons Fabricius, show both aspects, anticipating the modern technique of mixing photographs with measured drawings to give the maximum information about an archaeological find.

In the later 1750s Piranesi became a force in European archaeology and his attitude to Rome changed, perhaps imperceptibly, from that of a simple *vedutista* supplying a straightforward tourist demand to that of an investigator into the problems of construction and aesthetics which had faced the builders of ancient Rome. Just as he began to understand the outlook and achievements of his great predecessors he found that two foreigners, who ought to have known better, were challenging the supremacy of the architects of Republican and

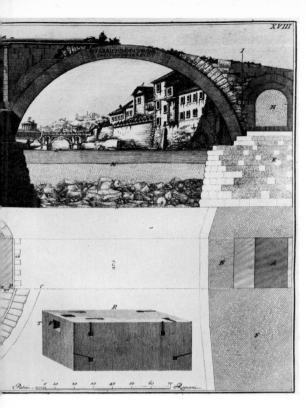

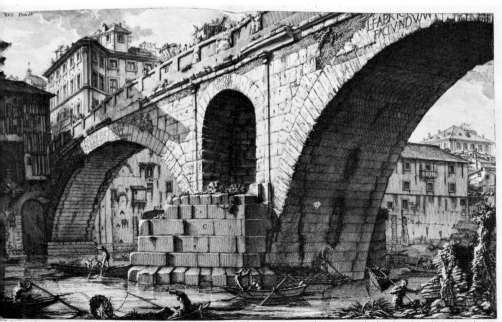

50, 51 *Piranesi*, Pons Fabricius, *etchings from* Antichità Romane, 1756.

Imperial Rome, and were setting up, against the men who built the Baths and the Pantheon, a handful of trifling little buildings in Greece, which was, in any case, a totally unimportant country inhabited equally by brigands and Turks. Winckelmann had come to live in Rome, immediately after the publication of his *Gedanken*, which extolled a purely mythical Greek restraint and nobility, and he was now the leading expert on antiquity in Rome and was even to become Papal Antiquary in 1763.

Julien-David Leroy, who had won the Prix de Rome in 1750 and had had the privilege of studying in Rome at the French Academy, had, in 1758, published a book called *Les Ruines des plus beaux monuments de la Grèce*. This was too much for Piranesi, who had already been provoked by a polemical article published anonymously in 1755 by the Scottish painter, Allan Ramsay.[29] The rather tepidly Hellenic ceiling-piece by Anton Raphael Mengs, the *Parnassus* (52) painted for the headquarters of Winckelmannism, the Villa Albani, and a singularly anaemic manifesto, was countered by Piranesi's publication of such splendid works of Roman art as Plate 53, which actually came from the Albani Collection. The publication in this way of urns, vases, sarcophagi and so on, with

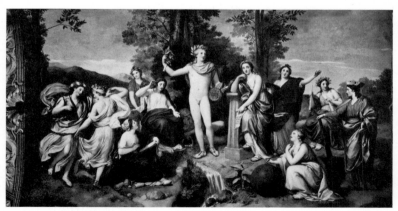

52 *Anton Raphael Mengs*, Parnassus, *fresco, 1761.*

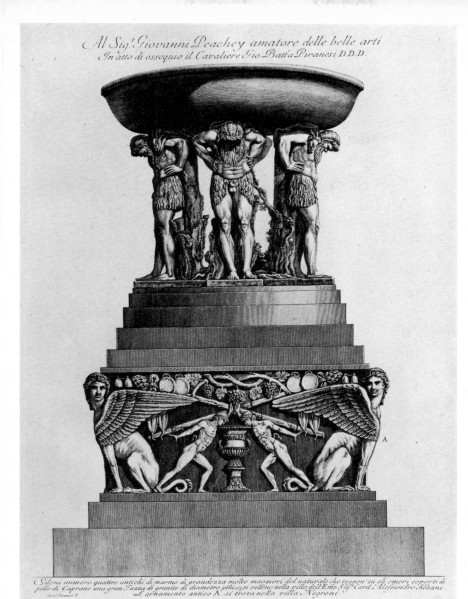

53 **Piranesi,** Dish supported by fauns, *etching dedicated to 'Giovanni Peachey', 1768 or later.*

54 *Piranesi*, *Frontispiece to* Della Magnificenza ed Architettura de' Romani, *etching, 1761.*

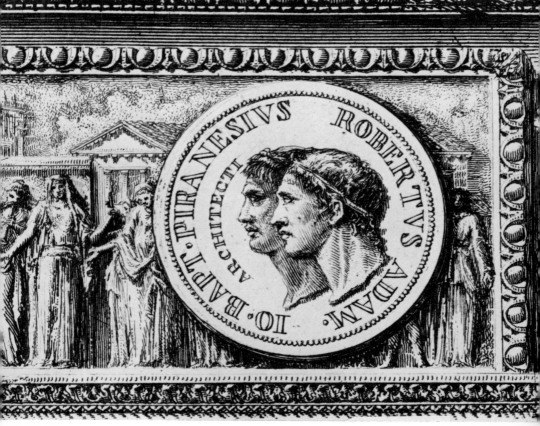

55 *Piranesi, detail of Robert Adam and Piranesi, from* Campus Martius, *etching, 1762.*

dedicatory inscriptions to various *milordi* or to his own friends, was a useful source of prestige and income. But his real answer to the Greek menace was the controversial *De Romanorum Magnificentia et Architectura* (54) of 1761, followed in 1765 by his *Parere su l'Architettura*, both of which have been the subject of a magisterial essay by Professor Wittkower.[30] Plate 55 shows a detail from the dedication of his elaborate reconstruction of the Campus Martius, with medallions of himself and of Robert Adam, an architect of eclectic

56 Piranesi, Plate from
Parere su
l'Architettura,
etching, 1765.

genius akin to his own. In works such as these Piranesi sought to
exert his new authority as a scholar, but he also came to recognize,
like Robert Adam, the overriding claims of genius. In one of the
plates of the *Parere* ridiculing Leroy (*56*), he invents a phantas-
magoria of Roman bric-à-brac, like a Surrealist *objet trouvé*, and he
gives it an ironic twist by inserting a quotation (in Roman letters)
from Leroy: 'Pour ne pas faire de cet art sublime un vil métier où
l'on ne feroit que copier sans choix', and in one of the very few
buildings actually erected by him, the Church and Piazza of the
Knights of Malta (*57, 58*), on the Aventine, he produced a weird
combination of Roman magnificence and the stage-design of the
eighteenth century. The Piazza would make an ideal setting for a
Scarlatti opera, especially with the benefit of modern Roman
floodlighting.

56

57, 58 Rome, *Piazza of the
Knights of Malta.*

To distinguish between Piranesi as an artist and as an archaeologist is not always easy, and he does not seem to have attempted to do so himself, although he was conscious of his position as an Honorary Fellow of the Society of Antiquaries; and his dedications to Robert Adam, as well as single plates dedicated to friends and colleagues like Jenkins, Byres, Gavin Hamilton, Sir William Hamilton and others, all show that when he prefaced the second volume of his major work, the *Antichità romane* (*59, 60*), with a reconstruction of the junction of the Via Appia and the Via Ardeatina he meant it to be taken seriously, not just as an imaginative exercise like the *Carceri d'Invenzione*. Horace Walpole had no doubts about Piranesi's imaginative power, when he wrote of 'The sublime dreams

59 Piranesi, drawing for Frontispiece of the Via Appia, from Antichità Romane, *1756.*

58

of Piranesi, who seems to have conceived visions of Rome beyond what it boasted even in the meridian of its splendour. Savage as Salvator Rosa, fierce as Michael Angelo, and exuberant as Rubens, he has imagined scenes that would startle geometry, and exhaust the Indies to realise.'[31] Walpole expresses the duality – almost dichotomy – of Piranesi's vision, as he walks his tightrope between arid anti-quarianism and full-blooded Romanticism, more concerned with effect than with truth (61, 62). He himself said, not immodestly, 'I do dare to believe that, like Horace, I have executed a work which will go down to posterity, and which will endure for as long as there are men desirous of knowing all that has survived until our day of the ruins of the most famous city of the universe.'[32]

60 Piranesi, *Frontispiece of the Via Appia from Vol. II of* Antichità Romane, *etching, 1756.*

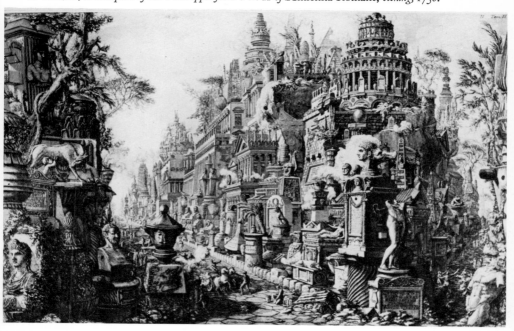

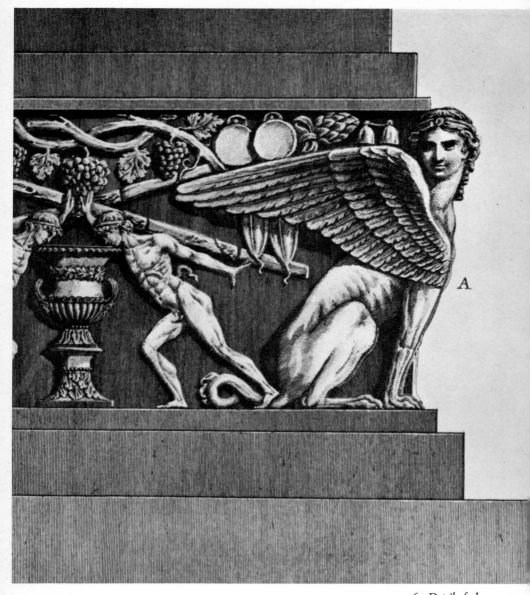

A

61 *Detail of pl. 53.*

62 *Piranesi*, Carcere d'Invenzione V, *etching, c. 1760.*

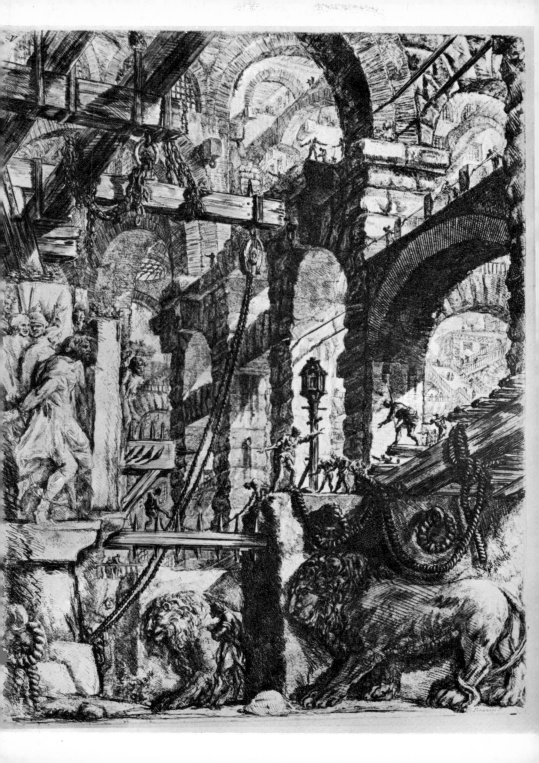

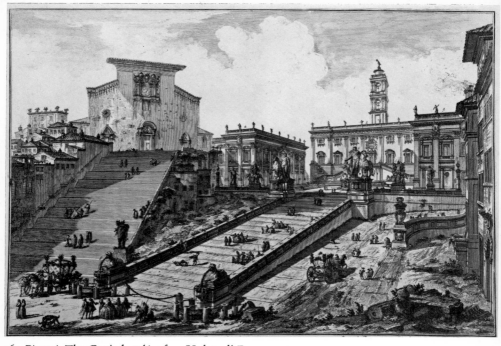

63 Piranesi, The Capitol, *etching from* Vedute di Roma, *1757.*

64 Piranesi, Forum, *etching from* Vedute di Roma, *1757.*

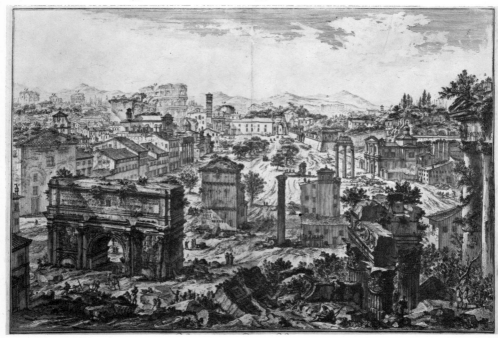

Yet the last word must come from one of the most celebrated passages in English literature, for it seems to me that Piranesi made not one but many generations see Rome as he saw it; the *Decline and Fall* would have been different without his vision of the grandeur of ancient Rome:

'It was at Rome, on the 15th of October, 1764, as I sat musing amidst the ruins of the Capitol, while the barefooted friars were singing vespers in the Temple of Jupiter, that the idea of writing the decline and fall of the city first started to my mind. But my original plan was circumscribed to the decay of the city rather than of the empire. . . .'[33]

That idea started to Gibbon's mind in Piranesi's lifetime, and only about seven years after he had published the etchings of the Capitol and Forum (*63* and *64*). In that lifetime he had given new eyes to his own century and had, in a small but significant way, affected the course of the Romantic movement, and thus influenced the consciousness of Western man. It is not a bad epitaph, and it is his claim to consideration as one of the great artists.

NOTES

1 F. Mauroner, *Luca Carlevarijs* (Venice, 1945), pp. 73–75, records five eighteenth-century eds. of *Le Fabriche, e Vedute di Venetia . . . intagliate da Luca Carlevarijs . . .* , Venice, with title-page dated 27 May 1703. The first ed. contains 100 plates, increased to 103 for the third ed.

2 One of these etchings is dated 1741, but the dedication to Consul Smith implies publication of the whole set in or after 1744, Smith being appointed Consul in the summer of that year.

3 The detail is from the *Veduta ideata di Venezia*, dated 1741. See J. Kainen, *The Etchings of Canaletto* (Washington, 1967), Plate 12b. This reproduction (Plate 11) is from the recently dis-covered impression in the Courtauld Institute.

4 By T. Pignatti. Stylistically I can see no grounds for the attribution.

5 M. Levey, *Canaletto Paintings in the Collection of H.M. The Queen* (Lon-don, 1964), p. 16: 'All [the five views of Rome] are prominently signed and dated 1742, and they constitute what evidence there is for supposing that Canaletto made a second journey to Rome in about 1740.'

6 The Pannini drawings are reproduced in W. Jeudwine, *Stage Designs* (R.I.B.A. Drawings series, 1968), Plates 28, 29.

7 Catalogue, *Giovanni Battista Piranesi, his predecessors and his heritage* (British Museum, 1968), no. 27.

8 Part III, no. 4. The escutcheon at the top is inscribed: *Misit eum Annus ligatum ad Caipham Pontificem. Ioh. xviii. 24.*

9 For the sequence of these plates see H. Focillon, *G.B. Piranesi. Essai de catalogue raisonné de son œuvre* (Paris (new impression), 1964). The *Stairs* and *Dark Prison* are F. 10 and F. 4 respectively.

10 *Theodora* was composed in 1749 and first produced, at Covent Garden, in 1750.

11 See W. Jeudwine, *op. cit.*, p. 44, and A. Hyatt Mayor, *The Bibiena Family* (New York, 1945).

12 Focillon, *op. cit.*, pp. 24 ff., dates the first 'Buzard' issue 1745 and the second 1760, but A. M. Hind, *Piranesi* (London, 1922), p. 81, points out that the 1792 catalogue of Piranesi's works refers to the first ed. as of 1750. He also distinguished between a second, 'Bouchard', impres-sion and Piranesi's own second ed. of *c.* 1761. See also the observations in Messrs Craddock and Barnard's Catalogues 109 and 122.

13 M. Goering in Thieme-Becker, XXXIII, p. 152, first pointed out that Tiepolo's *Capricci* go back at

least to 1743 and possibly to the 1730s although published in 1749. In fact, A. M. Zanetti published the *Vari Capricci* in 1743 and again in 1749.

14 Domenico Tiepolo's twenty-four plates of the *Fuga in Egitto* series (1753) and his *Via Crucis* (1757) are relevant in this connection.

15 Edmund Burke, *A Philosophical Inquiry into the Origin of our Ideas of the Sublime and Beautiful* . . . (London, 1757, and many other eighteenth-century eds.). French translation 1765; German 1773; Italian 1804. See M. Calvesi's introduction to the Catalogue of the G. B. and F. Piranesi Exhibition, Rome, Calcografia Nazionale, 1967–68, which also contains interesting remarks on the Mamertine Prison as a source for the *Carceri*.

16 Piranesi etched the plate of the *Villa Real dell'Ambrogiana* from a drawing by Zocchi now in the Pierpont Morgan Library, New York. The collection of Villas was published in 1744.

17 At least two examples of the *Varie vedute di Roma antica e moderna* with a title-page dated 1745 are now known – one in the Biblioteca Vittorio Emmanuele in Rome (*cf*. Catalogue *Il Settecento a Roma* (Rome, 1959), no. 462) and a second in the Henry Huntington Library in the US.

18 Jean Barbault (*c*. 1705–66) worked at the Académie de France à Rome and died in Rome. His paintings include a series of veiled women and are

sometimes confused with those of Subleyras. His engravings include *Les plus beaux Monumens de Rome ancienne* (1761), *Recueil de divers monuments . . .* (1770), and *Vues des plus beaux restes…* (1775), the latter two being posthumous, but evidence of a continuing demand. German editions also appeared. Giuseppe Vasi (1710–82) was a Sicilian, like Juvara, whose pupil he was. His numerous dull engravings of festive machines derive directly from the Bibiena-Juvara *pompes-funèbres* tradition. He arrived in Rome in 1736 and his major works are the huge twelve-sheet map (1765) and the *Nuova Pianta . . .* (1781). His *Magnificenza di Roma antica e moderna* clearly anticipated Piranesi's major works, but it lacks fire. See C. Olschki in *Emporium*, LXIV (1926), pp. 312–20; I have not been able to consult A. Petrucci, *Le Magnificenze di Roma di G. Vasi* (Rome, 1949).

19 For example, the Perelle landscape with a villa beside a lake, numbered '107'.

20 J. Harris, 'Le Geay, Piranesi and International Neo-Classicism in Rome, 1740–50' in *Essays in the History of Architecture presented to Rudolf Wittkower* (London, 1967), pp. 189ff.

21 H. Lapauze, *Histoire de l'Académie de France à Rome*, I (1924), p. 342: 'La chaleur de l'étude se perd le plus souvent soit par les connoissances soit par l'envie de gagner. On a eu un exempe [*sic*], il y a 30 ans, qu'un nommé Duflos, peintre d'histoire, qui avoit été huit ans pensionnaire sous

M. de Troye revint en France médiocre peintre de paysage.'

22 In Catalogue 122 (1971), *Piranesi and his Circle*, issued by Craddock and Barnard, London.

23 The column was removed in 1613 and now stands in front of Sta Maria Maggiore.

24 This example has the blind stamp 'Regia Calcografia' which was used between 1870 and 1945.

25 A. Giesecke in Thieme-Becker, XXVII. See also his monograph in the 'Meister der Graphik' series (1911).

26 See the catalogue in A. M. Hind, *op. cit.* Numbers 136 and 137 are by Francesco Piranesi.

27 Some of the plates in the *Antichità romane* are actually by Girolamo de' Rossi (III, F. 308).

28 Communicated by Mr Hugh Thompson, Assistant Secretary of the Society. Piranesi was admitted an Honorary Fellow on 7 April 1757, the same year as the election of Thomas Jenkins, painter and *virtuoso* at Rome, to whom Piranesi dedicated his frontispiece (F. 983) to the *Raccolta di alcuni disegni del . . . Guercino* (1764). The 'V Vols. Folio' presumably refers to the four volumes, much larger than folio, of the *Antichità romane* of 1756.

29 See R. Wittkower, 'Piranesi's *Parere su l'Architettura*' in *Journal of the Warburg Institute*, II (1938/9), pp. 147 ff., and also his essay in the Exhibition Catalogue *Piranesi* at Smith College, Northampton, Mass., 1961.

30 Wittkower, *Parere . . . cit.*

31 H. Walpole, 'Advertisement' to vol. IV of his *Anecdotes of Painting in England* (printed 1771; published 1780).

32 *Lettere di Giustificazione:* English version from A. Samuel, *Piranesi* (second ed. 1912), p. 19.

33 E. Gibbon, *Autobiography* (Everyman ed., London, 1932), p. 124.

CHRONOLOGICAL TABLE

1715 Pannini arrived in Rome

1717 Winckelmann born

1719 Probable date of Canaletto's first visit to Rome

1720 Piranesi born at Mogliano, near Mestre
Bellotto born

1723 Marco Ricci mentions his activity as 'incisore' in a letter

1725 Paolo Anesi, *Varie Vedute Inventate ed intagliate da Paolo Anesi Romo . . . 1725*. Set of twelve etchings, several of which were reworked and re-used for the *Varie Vedute . . .* of 1745.

1729 Pannini: *The Piazza Navona*, National Gallery of Ireland, Dublin

1730 Marco Ricci died: posthumous publication of his etchings, *Experimenta . . .*, with engraved frontispiece by Visentini
Luca Carlevaris died

c. 1733 Duflos arrived in Rome

1735 Visentini's *Prospectus Magni Canalis . . .*, engravings after Canaletto (second ed. 1742)

1736 Juvara and G. van Wittel died. Vasi arrived in Rome

1737 Le Geay arrived in Rome

1740 Piranesi arrived in Rome for the first time; studied with Vasi (?) and Polanzani (?). Giuseppe Galli Bibiena, *Architetture, e Prospettive*. Bellotto and Canaletto in Rome (?)

1741 Mengs in Rome for the first time, studying under Conca and Benefial. M. Marieschi, *Magnificentiores . . . Urbis Venetiarum Prospectus . . .*, twenty-one etchings of Venice. Dated etching by Canaletto, *Veduta ideata* of Venice

1742 Canaletto, five large paintings (Royal Collection) of Roman *vedute*. Pannini, *Sta Maria Maggiore*, Rome, Quirinal. Le Geay returned to Paris from Rome (his plates in *Varie vedute . . .* are therefore 1737/42). J. Barbault arrived in Rome *c.* 1742

1743 Piranesi, *Prima Parte di Architetture e Prospettive* published in Rome; returned to Venice 1743/44. G. B. Tiepolo *Capricci* etchings first published by A. M. Zanetti in Venice; twenty-four etchings by M. Ricci published in Venice. Vien won the Prix de Rome

1744 Vien arrived in Rome. Piranesi wrote (March) to Mgr Bottari, the Vatican Librarian, informing him of his arrival in Venice and thanking him for his help in Rome; Piranesi perhaps in Tiepolo's studio and possibly working on the *Carceri* (I) and *Grotteschi*. Joseph Smith made British Consul in Venice (earliest date for Canaletto's etchings as a suite). Piranesi etched the plate the *Villa Real dell'Ambrogiana* from a drawing by G. Zocchi in his *Ville . . .* published in Florence. Piranesi returned to Rome and settled there 1744/45

1745 Piranesi's Tiepolesque *Capricci* and the first *Carceri* probably etched: the *Carceri* not published until *c*. 1750. Plates by Piranesi appeared in the first ed. of *Varie vedute di Roma antica e moderna* . . . with others by Anesi, Bellicard, Duflos and Le Geay (cf. 1742) – copies of this very rare ed. in Rome and California. Pannini's two large paintings *Charles III's Visit to Rome*, Naples

1746 Duflos died in Lyons. Canaletto went to London. Vasi, *Fontana di Trevi*

1747 Mengs in Rome for the second time. Bellotto went to Dresden. Bellicard won the Prix de Rome. Vasi, *Magnificenze* . . . first plates (ten vols, to 1761)

1748 Piranesi published the first plates of the *Vedute di Roma* (Title, frontispiece, three plates of St Peter's, San Paolo fuori: H. 1–6 inclusive); second ed. of *Varie vedute* . . . but many copies have plates dated 1750; *Antichità romane de' tempi della repubblica e de' primi imperatori*. . . . J.-L. David born

1749 Reynolds arrived in Italy. Clérisseau won Prix de Rome

1750 Probable date of first issue of Piranesi's *Invenzioni capric. di Carceri* . . .; *Opere varie* . . . (i.e. reprint of *Prima Parte di Architetture* . . . and *Capricci* with additions). Dated plates by Bellicard for the *Varie vedute*. . . . Richard Wilson arrived in Rome

1752 Piranesi married and began work on *Antichità romane* (published 1756). Mengs in Rome for third visit

1754 Pannini Principe of Accademia di San Luca. Hubert Robert arrived in Rome

1755 J. J. Winckelmann, *Gedanken über die Nachahmung der griechischen Werke* . . . published in Germany; Winckelmann arrived in Rome (November). R. Adam arrived in Rome, visited antiquities with Piranesi. 'The Investigator' (= Allan Ramsay) attacks Roman art and exalts Greek. Vien in Rome again

1756 Piranesi published all four volumes of the *Antichità romane*

1757 Piranesi's *Lettere di Giustificazione scritte a Milord Charlemont* . . . concerning the dedications of *Antichità romane*. Piranesi elected an Honorary Fellow of the Society of Antiquaries of London, and T. Jenkins elected Fellow. Publication of vol. 1 of *Le Antichità di Ercolano* . . . describing the works being excavated in Herculaneum. Mengs, ceiling of Sant'Eusebio, Rome

1758 J.-D. Leroy, *Les Ruines des plus beaux monuments de la Grèce*

1759 Winckelmann appointed Librarian to Cardinal Albani. Opening of the British Museum

1760 Piranesi, second ed. of *Carceri* (1760/61). Winckelmann, *Description des pierres gravées du feu Baron Stosch*

1761 Piranesi, *Della Magnificenza ed Architettura de' Romani* . . .; Gavin Hamilton and Piranesi admitted to the Accademia di San Luca, Rome, on the same day. Mengs,

Parnassus, Villa Albani; Winckel-mann, *Anmerkungen über die Baukunst der Alten* . . .; J. Barbault, *Les plus beaux monumens de Rome ancienne* (128 plates); completion of Vasi's *Magnificenze* . . .

1762 Piranesi, *Campo Marzio* (dedicated to Robert Adam); *Lago d'Albano*...; *Lapides Capitolini* . . .; Winckel-mann, *Sendschreiben von den Her-culanischen Entdeckungen*; Stuart and Revett, *Antiquities of Athens*, vol. I; MacPherson, *Fingal* ('Ossian')

1763 Winckelmann appointed Praefector Antiquitatum of Rome. Vasi, *Itinerario istruttivo* . . .; MacPherson, *Temor* ('Ossian')

1764 Piranesi began Sta Maria del Priorato and Piazza dei Cavalieri di Malta (to 1766). Winckelmann, *Geschichte der Kunst des Alterthums*. Houdon arrived in Rome. Gibbon decided to write a history of Rome

1765 Piranesi, *Parere su l'Architettura* and *Osservazioni* . . . *sopra la lettre de M. Mariette* . . .; knighted by the Pope (plates signed 'Cavaliere', e.g. H. 75–77). Vasi's map of Rome. Pannini died (1765/68)

1766 Barry arrived in Rome. Houdon, *S. Bruno*. Lessing, *Laokoon*. Pira-nesi, *A View of the intended bridge at Blackfriars* . . . *1764, by Robert Mylne* . . . *Engraved by Piranesi at Rome*. Anesi and Barbault died

1767 Winckelmann, *Monumenti antichi inediti* . . . , vols I and II (vol. III, 1772)

1768 Piranesi began *Vasi, candelabri* . . . (continued to his death); Le Geay, *Rovine, Tombeaux*, and *Vasi* sets of Piranesian etchings. Winckelmann

murdered. Foundation of the Royal Academy, London

1769 Piranesi, *Diverse Maniere d'adornare i cammini* . . .; Reynolds, *First Discourse*

1770 Fuseli arrived in Rome. Barbault, *Recueil de divers monuments* . . . *de l'Italie* (posthumous) – 'Pour servir de suite aux *Monuments de Rome ancienne*'

1771 Piranesi, *Rovine del Castello dell' Acqua Giulia*; Forcellini, *Totius Latinitatis Lexicon*. Mengs Principe of the Accademia di San Luca, Goya arrived in Rome

1772 Mengs's frescoes in the Vatican. Winckelmann, *Monumenti antichi* . . . , vol. III

1774 Goethe, *Werther*. David won Prix de Rome

1775 Vien appointed Director of the Académie de France à Rome, and arrived with David. Barbault, *Vues des plus beaux restes des antiquités romaines* . . . (posthumous)

1776 Gibbon, *Decline and Fall* . . . , vol. I (completed 1788)

1778 Piranesi, last of the *Vedute di Roma* series (H. 135); date on plates in R. and J. Adam, *Works in Archi-tecture*, II, etched by Piranesi; journey to Naples and Paestum for *Différentes vues* . . . *de Pesto*; died 9 November

1779 Mengs died. Tischbein in Rome. Bianconi's *Life* of Piranesi

1780 Bianconi, *Elogio del Cav. Mengs*. Canova's first visit to Rome

1786 Vasi, *Raccolta delle più belle vedute* . . . (posthumous)

LIST AND SOURCES OF ILLUSTRATIONS

19 Giovanni Battista Piranesi
Drawing after Javara's scenery for
Teodosio il Giovane, c. 1747/53
London, British Museum

20 Giuseppe Galli Bibiena
Christ before Caiphas
Engraving from *Architetture, e Pro-
spettive*, Part III, no. 4, 1740

21 Giovanni Battista Piranesi
Atrio reale (Royal Atrium)
Etching from *Opere varie*, 1750

22 Giovanni Battista Piranesi
Gruppo di Scale (Stairs)
Etching from *Prima Parte di Architet-
ture e Prospettive . . .* , 1743. (F. 10)

23 Giovanni Battista Piranesi
Carcere oscura (Dark Prison)
Etching from *Prima Parte di Architet-
ture e Prospettive . . .* , 1743. (F. 4)

24 Ferdinando Bibiena
Prison interior
Engraving for stage set design, 1703/8
London, British Museum, Depart-
ment of Prints and Drawings

25 Ferdinando Bibiena
Prison
Watercolour
Vienna, Albertina

26 Giovanni Battista Piranesi
First state of *Carceri d'Invenzione*,
1745–50
Etching (F. 39)

27 Giovanni Battista Piranesi
Second state of *Carceri d'Invenzione*,
1760
Etching (F. 39)

28 Giovanni Battista Piranesi
Il Delubro
Etching from *Descrizione e disegno
dell'Emissario del Lago Albano*, 1762
(F. 500)

29 Giovanni Battista Tiepolo
Capriccio
Etching, 1743 or earlier (De V. 10)

30 Giovanni Battista Piranesi
Capriccio
Etching, *c.* 1743 (F. 23)

31 Giuseppe Vasi
Campo Vaccino
Etching from *Magnificenza di Roma
antica e moderna*, 1747

32 Jean Barbault
The Portico of Octavia
Etching from *Les plus beaux Monumens
de Rome ancienne*, 1761

33 Charles Bellicard
Nero's Tomb
Etching, dated 1750
From *Varie vedute di Roma antica e
moderna*, first published 1748

34 François Philotée Duflos
Temple of Bacchus
Etching from *Varie Vedute di Roma
antica e moderna*, first published 1748

35 François Philotée Duflos
Basilica of Maxentius
Etching from *Varie Vedute di Roma
antica e moderna*, first published 1748

36 Etienne Dupérac
Basilica of Maxentius
Engraving from *I Vestigi dell'Anti-
chità di Roma*, first published 1575

37 Giovanni Battista Piranesi
Basilica of Maxentius
Etching from *Vedute di Roma*, 1757
(H. 45)

38 Giovanni Battista Piranesi
Basilica of Maxentius
Etching from *Antichità Romane*, 1756
(F. 208)

39 Jacques Callot
Etching from *Les Caprices*, 1617/21
(M. 776)

40 Giovanni Battista Piranesi
Basilica of Maxentius
Etching from *Vedute di Roma*, 1774
(H. 114)

41 Rome, Basilica of Maxentius